From Science to Zenga: About Kaeru-An

蛙菴

Kaeru-An is the Japanese name of my Zen art collection. Falling in love with Japanese Zen art; how could this happen to me? Here is my personal story: first scientist, then artist, now Zenga lover.

When I was very young I wanted to understand everything, the whole cosmos! Later in university, I chose physics as my major field of study. A great example for me was Albert Einstein, and my aim was to study and explore the most fundamental physics. However, it did not turn out that way.

During my student years I became interested in boomerang flight and I wanted to know how such a strange phenomenon is possible. I decided to investigate this on my own and began my research in my free hours. A creative professor offered me the opportunity to continue my boomerang research as a PhD project. This involved a lot of math, a lot of experiments, and reading everything I could find about boomerangs, most of it written by ethnologists. Since the Aboriginal people of Australia are well known for their use of boomerangs, I decided to find a job in Australia. After completing my doctoral thesis on the aerodynamics and motion of boomerangs in 1975 I moved from Holland to Australia and for some years I worked in Adelaide as a mathematician.

There, in the hills where I lived was a small creek along the garden's edge. At night, hundreds of small frogs were calling, generating amazing natural concerts, with rhythms and waves of sound that enthralled me. Such concerts were never predictable, they were spontaneous and very spatial. Here I first met the frogs of Australia; here my listening began. At night, I was spellbound; I could not stop listening. Later, as I travelled in the outback and camped in very quiet spots, the beauty of the nights was overwhelming, the richness of the sounds unending, and frogs became my teachers before I even was aware of it. Frogs are listeners too. I had quickly noticed this, since frogs would stop calling when I approached them; they sensed my footsteps. I bought sound recording equipment and began making stereo recordings of frog choruses. I had to find active frogs in very quiet places, moving through landscapes with ears wide open and exploring the space all around me. I had to locate good spots for my microphones. I had to judge the spatial distribution of frog calls, the balance and depth of the chorus, and the presence of unwanted sounds such as rumblings of faraway trucks or the wind's turbulence in

the mikes. I had to sit still and be attentive to all sounds around me: the frogs, the insects, the wind, the rain, the distant trucks and airplanes, really everything active, night after night after night. I learned to just sit still in silence and listen. The concerts were never the same, they were influenced by ambient sounds, by how warm and how humid it was, by the time of the year and the time of the night, by the wind, by the clouds and the moonlight, and by things unknown to me; they were always utterly fresh. I was enchanted by the frogs of Australia; those were wonderful nights!

After my return to Holland, I played back those recordings, which sounded beautiful indeed, but something was missing; the recorded concerts were not alive. I had wondered how the waves and rhythms of frog choruses could emerge from groups of singers with no conductor and no score, and I asked myself this question: Frogs listen; on hearing conspecific calls their eagerness to call goes up; on hearing other sounds their eagerness goes down; is this what causes wavelike rhythms to emerge? I wanted to find out by making small machines based on those principles. In 1982 my first electronic sound creatures were built. They actually worked: the acoustic interactions between the small machines created wavelike rhythms that were influenced by the acoustics of the space, the machines' positions and, of course, the ambient sounds. I had a live chorus of electronic sound creatures! Considering this a scientific model of the group behaviour of animals such as frogs, I demonstrated the sound creatures to biologists. They were interested, but more reactions came from people working with experimental music and art, who told me "this is art" and "you are an artist"—so I found I had become an artist. But, whatever name was given to my work, I saw it as research, and I still do. [1]

In the 1990's I was often in Japan, invited to present my work as an artist. I visited many of the Zen gardens in Kyoto; temple gardens, exquisitely designed to calm the mind. In 1992 for the first time I attended a Nō performance. This traditional form of theatre was beyond anything I could have imagined. With friends I enjoyed informal tea ceremonies. These three aspects of Japanese culture are all imbued with a Zen Buddhist feeling. At that time in Japan, after talking with art students about my work, I thought again about the frogs of Australia: more than ten years had passed when I suddenly realised that those frogs actually were my teachers! During all those nights when I was trying to make the best possible sound recordings of their concerts, without my knowing, straightaway they taught me to **just sit still in silence and listen**. So I am grateful to the frogs.

My interest in Zen Buddhism was aroused. Some of the books about Zen showed pictures of Zen art, but I had never seen such art in the real. I could not have guessed what was in store for me. On a summer evening in 2001, during a visit to the Museum für Ostasiatische Kunst in Berlin-Dahlem, suddenly I found myself standing face to face with Zen art, half a

dozen hanging scrolls with vertical one-line calligraphies. I was immediately overwhelmed by the extraordinary power radiating from these artworks; never had I experienced anything like this! The characters, brushed with such an unbelievable power, surely represented something profound but the labels gave no explanation. A year later I noticed on the internet that there were Zen scrolls for sale. I decided to buy one piece, which seemed to equal the best calligraphy I'd seen in Dahlem. ([K001], not in the exhibition) It was by Zen master Zentatsu (1669-1749); its five characters say *Joyful Form Moves Heaven Earth*. I received it in my home as a honoured guest. For three weeks it kept on surpassing my expectations. I found it hard to switch off the light at night when I had to go to bed. Sometimes I went downstairs again to have one more look, and in the mornings this piece looked better still. From my early notes: "How can I be so fortunate! First of all it is the artwork, the commanding brushstrokes, utterly convincing, powerful and amazingly full of life. Second it is the patina, the mounting, the dignified condition of the scroll as a whole. The vigor, the beauty, the power, the masculine energy, is indescribable. If I can point to just one man-made object in my life that surpasses all, it is this Zentatsu. I still find it almost unbelievable that I am its 'owner'." I became hooked on Zen art. I could not refrain from buying more and more pieces, and I always asked for, and was given by my adviser Prof. John Stevens, the original texts—mostly Chinese characters—in printed form, English translations, and information about the artists. It is amazing how their individual personalities come out in these extraordinary art forms. Again from my early notes: "[K021] Tokuō. This is truly a wonderful Ensō. Very beautiful indeed! It radiates calm, even when it's in the room without my looking at it. So sensitive, powerful, such intimate dignity. There could be nothing better. I'm speechless." And recently, about the majestic one-line calligraphy by Ishikawa Jōzan [K536]: "This Jōzan scroll is truly impressive! The mounting too is very good. The only way to have a good view of this piece would be by sitting on tatami. So, on the spur of the moment, I ordered tatami mats from Berlin."

Today there are over 500 pieces in my collection, which I named 蛙菴 **Kaeru-An**, meaning "Frog Hut", in honour of my original teachers, the frogs. These artworks have become my dear friends and teachers. What exactly they are teaching me I cannot say; it's a feeling… They seem to be timeless, so fresh they are; brushed centuries ago, many look like they were made today. I am extraordinarily fortunate to be surrounded by such wonderful artworks within touching distance. The mind-sets of the Zen artists manifest with a startling immediacy; this is no ordinary art! Now 15 special Zenga are on display in Kunstmuseum Bochum. I hope you enjoy seeing them.

<div style="text-align: right;">Felix Hess, summer 2011</div>

Note:

(1) Bernd Schulz (ed.) *Felix Hess: Light as Air* Kehrer Verlag, Heidelberg 2001.

喜
色
動
天
地

Joyful
Form
Moves
Heaven
Earth

K001 (not in exhibition)
ZENTATSU Gyōnei (1669-1949)
one-line calligraphy
hanging scroll 204 cm × 39 cm,
ink on paper 128.2 cm × 34.8 cm.

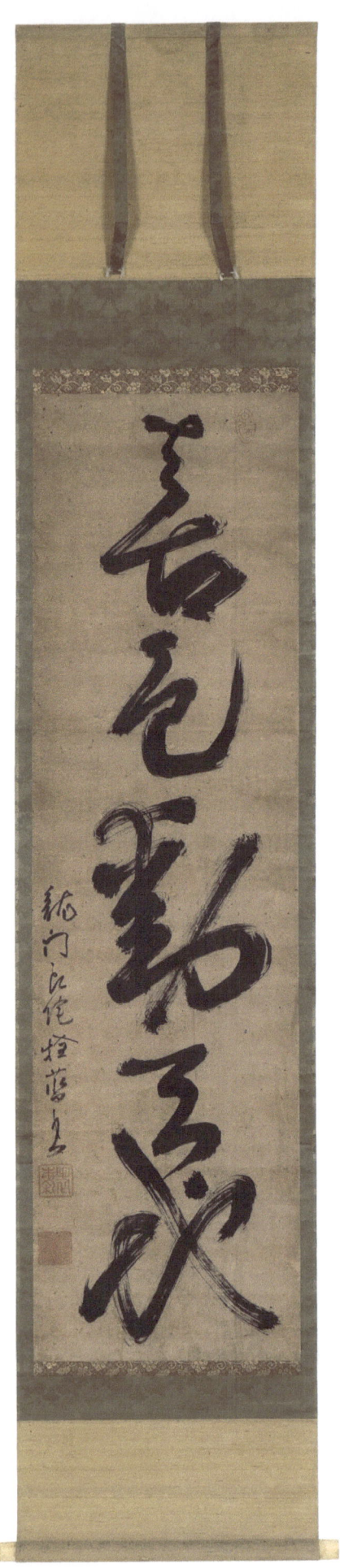

ZENGA: THE PRESENT ART

John Stevens

Terms used to describe modern art include "abstract," "minimalist," "performance," "spontaneous," "idiosyncratic," "unconventional," "expressive," or "subjective." In short, much modern and contemporary art attempts "to express meaning rather than physical reality in a revolutionary new manner."

However, "expressing meaning rather than physical reality" is nothing new, at least in the Buddhist tradition of art. In the earliest period of Buddhist art, an image of Buddha was not there. Buddha was represented by an empty chair, the tree of life, a riderless horse, a stupa, the wheel of the Dharma, or a footprint. (The image of Buddha's footprint is still in wide use today.) Buddha-hood was, after all, a direct and immediate vision of reality in the here and now. In essence, "If you are awakened, you see Buddha-nature right in front of your face so why try to represent it with an image?"

On the highest level that is certainly true, but most human beings in fact actually do need an image, an aid, a tool, a stepping-stone, a guide to contemplate. Thereafter, conventional Buddhist art tried to be as realistic as possible. Buddhas, Bodhisattvas, saints, sages, kings, queens, monks, nuns, and laypeople were portrayed as actual human beings—albeit idealized—perfectly formed and elaborately outfitted. Buddhist sculptures and paintings were dramas that depicted immediately recognizable people and events in careful and minute detail.

However, other Buddhists continued to maintain that excessive reliance on physical characteristics was too confining. In the *Platform Sutra of the Sixth Patriarch* (Hui-neng, 638-714) there is this story:

> The abbot of the monastery had commissioned a painting of his predecessors for the monastery wall. However, he suddenly thought: "The Diamond Sutra says, 'All images are ultimately false.'" Fearing that his disciples would adhere too closely to the realistic pictures, he had the dueling poems that had been written there overnight by his two top disciples left on the wall. He concluded that the stark characters against a white wall and the puzzling nature of the verses better suited to awaken the mind. [1]

The earliest record of a Zen painting is from 9th century China:

> A monk asked his master for something written down to inspire and instruct him. The master refused, saying, "Buddha-nature is right in front of your face so why should I express it with brush and ink?" The monk then went to visit Master Kyōzan (Yang-shan) with a plea for something concrete. Kyōzan drew a circle on a piece of paper and added this inscription: "Thinking about this and understanding it is second best; not thinking about it and understanding it third best."

The Zen riddle to be solved being, "What is first best?" (Transmission of the Lamp.)

That Zen circle was an *ensō*. Ensō have been considered the symbol supreme of Zen throughout the centuries. Ensō are not only brushed in ink on paper. Here are two such examples, both cases being "Zen performance art."

> Zen master Amban (An-wan) told his students, "Stop trying to explain the teaching of Buddha, it is inconceivable." He then drew a circle in the air and declared, "All the written scriptures and all the teachings are in here!" (Mumonkan, case 49.)

> Nansen (Nan-ch'uan) went to visit master Baso (Ma-tsu). Baso drew a circle on the ground and challenged, "If you enter it, I will hit you with my staff. If you don't enter, I will hit you anyway." Nansen immediately stepped into the circle. Baso struck him as hard as he could. Nansen said, "You missed me by a mile!" (Chronicles of Master Baso.)

An ensō is the simplest of forms, but it can be brushed in many ways: from the bottom, from the top, from the side, clockwise, counter-clockwise, in separate half-circles; the shape can range from perfectly symmetrical to completely lopsided, and degrees of thickness, from thin and delicate to fat and solid. The ensō can be placed anywhere on the paper: to one side, in the middle, in a corner, top or bottom. It can be interpreted as symbolizing: everything, nothing, infinity, eternity, perfection, enlightenment, the bright moon, mind, heart, center, a cookie, a fist, a frying pan, the top of a bucket, a bald head. An ensō, in short, is perfectly abstract and minimalist, endlessly subjective and—this is the best part—instructive, inspiring, and enlightening, regardless if it was brushed a thousand years ago or yesterday.

There are three ensō on display in this exhibition. The oldest, dating from the 17th century is by Tōkuō. [K021] This ensō is on the bottom, and on the top is the most common inscription on ensō paintings: "What is this?" It is up to the viewer to decide. The second ensō, by Rōran,

is placed right in the middle. [K226] The inscription could be used by a quantum physicist to describe reality: "Nothing lacking, nothing extra." [2] The third is a zero—"Not one thing"—ensō by Gōchō. [K502] Interestingly, while eccentric Gōchō was capable of painting classic Buddhist icons, within all the strictly defined dictates, his Zen brushwork is completely uninhibited, idiosyncratic as can be, but therefore immediately recognizable as his work.

Moving from abstract brushwork to portrait painting, in the exhibition there are three portraits of Daruma (Bodhidharma), the legendary grand patriarch of Zen, by the great Zen artists: Fūgai, Hakuin, and Sengai. The paintings can immediately be recognized as Daruma, but all have distinctive personalities, so to speak. Daruma is not painted as a historical figure but as a symbol of insight, self-reliance, and the rejection of abstract concepts and meaningless ritual. In order to paint Daruma one must become Daruma. (Dante wrote: "Who paints a figure, if he cannot be it, he cannot draw it.") Thus a painting of Daruma is a spiritual self-portrait.

Fūgai lived most of his life as a hermit, so his Daruma is austere, reserved, and intense. (And technically the best painting of the three.) [K519] Although Hakuin's Darumas are usually over-powering—like he was himself as a dynamic Zen master—the one in the exhibition is rather wily, with his eye fixed on the viewer, as if to say, "I can see right through you!" [K206] Free-spirited Sengai brushed his Daruma with great good humor. [K508] Sengai is considered to be one of the inspirations for modern manga, and his zany Zenga are indeed enlightened cartoons.

The fourth Daruma, by Daikō, is also cartoon-like with the humorous message: "This is supposed to be a portrait of Daruma facing the wall in his cave but it actually looks more like a tasty melon or eggplant!" [K065] If sitting endlessly is all there is to Zen, melons and eggplants have it made. A Zen student must taste the core of Daruma's teaching and not be content with the outer skin. Daikō's equally simple and similarly delightful painting of tōfu also has a deep meaning. [K469] Tōfu is made from tough soybeans (raw human nature) but through processing (Zen training) it becomes pliable and nourishing (a good Zen student). Not to mention that tōfu is a perfect Zen food—inexpensive, delicious, and healthy.

One thing that should be mentioned is that Hakuin's and Sengai's work is in a sense "anti-art," that is not consciously created to be "beautiful." Hakuin never corrected mistakes or omissions in his calligraphy and if the pieces had drips, splashes, or catpaw tracks on them so much the better. For some of his larger works, Hakuin made an outline but instead of erasing it, he drew over it, producing a kind of "3-D" effect. Ink and paper was never wasted. Many of Hakuin's masterpieces were created with leftover congealed ink. Sengai carefully pieced together scraps of paper to form sheets that he could paint on.

In the same vein, the famous 20th century Shintō shaman and artist Onisaburō Deguchi (1871-1947) once accidently spilled a bucket of ink on a large sheet of paper he planned to use for calligraphy. Without skipping a beat, Onisaburō grabbed the paper and formed a moon and landscape with the splashed ink. This seems to me to be a cut above the drip paintings of Jackson Pollock (1912-1956), active the same time as Onisaburō, because Pollock's drips were intentional.

Speaking personally, once I was doing calligraphy at my Japanese home in Sendai. Japanese houses are completely open during the warmer months, and a sparrow happened to fly into the room looking for crumbs. It stepped into the pool of ink on the ink stone and hopped across the paper I was planning to use, leaving little claw marks. I composed this impromptu haiku and wrote on the paper:

Traces of ink,
Traced across the paper
By bird claw tracks.

In another sense, Zen painting can be considered "outsider art." An important Japanese art critic stated: "Zen painting is fun to look at but it is not art." How true, actually—it is not art for the sake of art, a decoration, a thing pleasing to look at but rather brushstrokes of enlightenment that provoke and challenge the viewer. Zen art—all good art—depicts the inner beauty of a thing rather than its outer form. The Zen artist depicts what he or she has experienced and knows to be true rather than a theoretical model.

Returning to the examples in the exhibition, the ultimate expression of Zen performance art is found in the creation of magic dragons. Gansui was likely a wandering mountain wizard (*yamabushi*). [K448] When he came to the particular village where he created this dragon, the people brought a large sheet of paper to the square. With a huge brush, and a terrific shout, Gansui brushed the dragon in one stroke with one breath. After being animated in this manner by the holy man, the dragon was believed to protect a family from the seven disasters: fire, floods, drought, earthquakes, pestilence, war, and irate fathers.

Chingyū's magic dragon is equally intriguing. [K320] This dragon is more mysterious, ethereal, and seems to be floating in air (even though it is on brushed on a piece of paper). Tesshū's magic dragon is much more substantial, soaring above Mt. Fuji. [K476] Mt. Fuji is the most common theme in all of Japanese art but the hardest to paint convincingly. While most conventional paintings of Fuji attempt to capture the mountain's outer beauty, the Zen artist wants to capture its essence, its Buddha-nature, with as few strokes as possible. And it works. Sengai's Mt. Fuji

looks solid and beautiful, without trying to be so. [K499]

Nothing can be more minimalist than the Zen staff, used to discipline errant monks, and a good painting of one like that of Unmon has a substantial, three-dimensional appearance. [K085] A staff like this also stands for something else hard and rigid. (Zen art has a definite sexual element to it.) On first glance, Tōrei's staff seems less formidable but gradually feels more and more threatening. [K475] The calligraphy along the sides gives the viewer no room to escape—the meaning of the inscription can be interpreted as "Here it comes ready or not!"

Ishikawa Jōzan's dramatic one-line calligraphy is a bold statement wherever it is displayed. [K536] It once hung in a teahouse or Zen temple in faraway Japan but now it has traveled to Europe. Even though it is more than 350 years old, the scroll is not out of place hanging in a museum of contemporary art. The meaning of the calligraphy—"One Thought Three Thousand"—is as profound and challenging as can be but the four characters composing the saying are among the simplest images possible. The stroke representing "one" is recognizable everywhere (even by illiterates). "Three" (the three brushstrokes of the third character) is a little harder to discern due to the delightful duck-like strokes of the top two. However, once that is pointed out the nature of the character ("three") becomes clear. The other two characters—"thought" and "thousand"—are known to every elementary school student in China and Japan. Simple is best.

Certain kinds of modern art are often described as being "provocative" and "irreverent" if not outright "rebellious," wanting to break down all conventions and seeking freedom from all restraints. Regarding this approach in Buddhist art, there is the story, "Tanka Burning the Buddha Image," often painted by Sengai:

> One winter, Tanka (an eighth century Chinese monk) was staying at a temple. It was unbearably cold, so in order not to freeze to death, Tanka took down a wooden Buddha-image from the altar and made a fire with it. When the temple master expressed his outrage at this sacrilegious act, Tanka told him, "Buddha made a vow to save all sentient beings so this wooden one can now save me!"

The one factor that distinguishes Buddhist art is the emphasis on creation of art based on "insight developed from years of meditation"—meditation not only done on a cushion, of course, but meditation maintained in all acts of life. Especially in Zen art [3], focus, vision, and experience of Buddhist truths are far more important than the skill of the hands. When asked how long it took to paint a Daruma, Hakuin replied, "Five minutes and eighty years."

The other meaning of Zen is "everything, totality, completely." Whatever the era, whatever the medium, whatever the genre, genuine art tells the truth. A true artist, east or west, past or present, strives to present his or her vision, a vision that Buddhists believe should be liberating both for the artist and his or her audience.

Notes:

(1) The two poems:

> *The body is a tree of enlightenment;*
> *The mind is like a polished mirror,*
> *Keep it clean always,*
> *Don't let dust gather*

by Shen-hsiu; booby prize;

> *Enlightenment has no tree;*
> *The mind does not need to be polished*
> *Originally there is not one thing*
> *So how can dust alight anywhere?*

by Hui-neng; winning entry.

(2) See "The Quantum and the Lotus" by Matthieu Ricard & Trinh Xuan-Thuan (New York, Three Rivers Press, 2001).

(3) This essay focuses on Zen Buddhist pictorial art, which I (and many others) believe has the most in common with modern and contemporary art. However, most of the points made in the essay can be applied to other forms of Buddhist art such as sculpture, ritual instruments, textiles, ceramics, etc. Also, the fantastic, mind-blowing psychocosmogram mandala of Buddhist Tantra are clearly surrealist art, and modern color field paintings by, for example, Mark Rothko look exactly like ancient Tantric color pattern images. There are many other parallels between Tantric art and modern art to be explored, at another time.

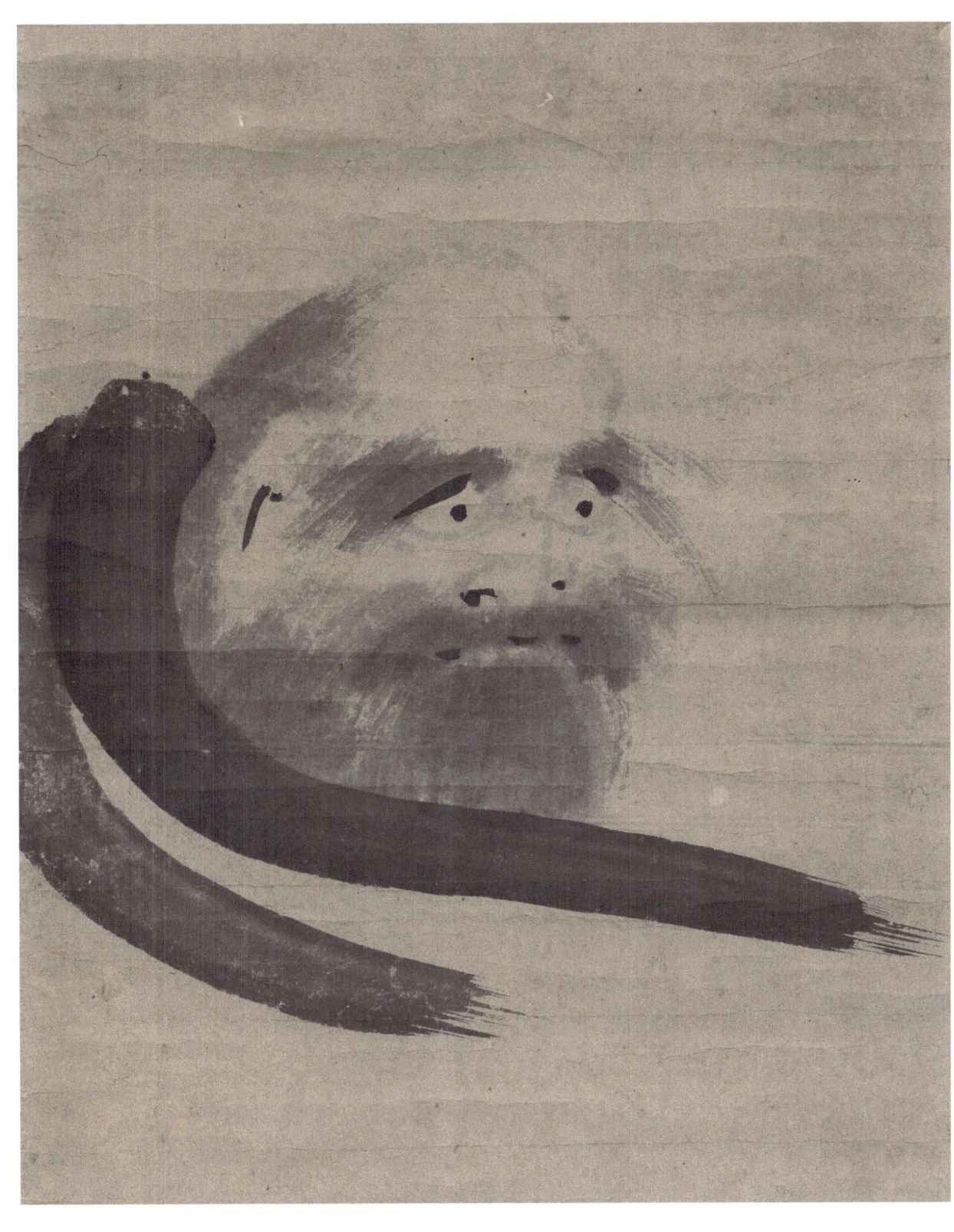

K519 **FŪGAI** Ekun (1568-1654) Daruma (detail)

TOKUŌ Ryōkō (德翁良高, 1649-1709)

Ensō

Inscription:

是　　　良
甚　咄　高
麼　　　書

What is this?
TOTSU!!
Brushed by Ryōkō

"What is this?" is the most frequent inscription on Zen circle paintings. "Totsu!" is a penetrating Zen shout, designed to awaken a student from his or her stupor. It is very similar to the more commonly known expression "Katsu!" Used as an inscription on an enso, "What is this?" is a visual koan—"Is this circle your (Buddha-) mind, the universe, the moon of enlightenment, zero, a rice cake, or maybe just the top of a bucket?" With the addition of the character Totsu, Tokuō demands further, "Don't think, Don't think!" Tokuō himself pondered the koans that he received from his master so deeply that he forgot to eat or sleep. Tokuō had two enlightenment experiences in the Meditation Hall, but neither came when he was doing zazen. The first occurred while he was stretching his legs during walking meditation, and the second came when he was preparing incense before the session began. The brushstrokes in this piece are especially rich and luminous.

K021 hanging scroll 168 cm × 35 cm, ink on paper 76.9 cm × 25.4 cm.

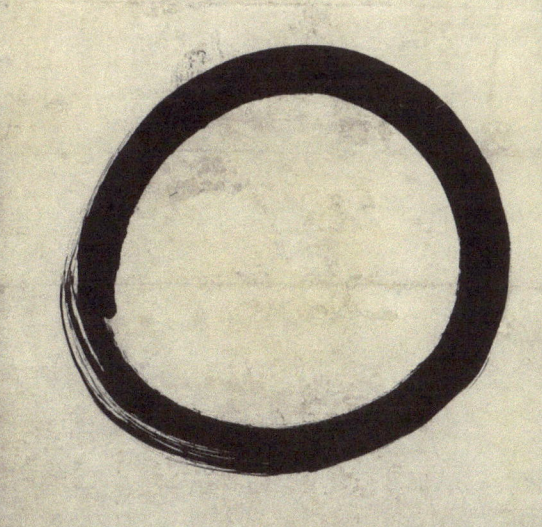

Fuyō RŌRAN (父幼老卵, 1724-1805)

Ensō

Inscription:

無欠無余
老卵書

Nothing lacking, Nothing extra.
Brushed by Rōran [Old Egg]

This is a wonderful example of a "perfection" ensō. Buddha-nature is complete within itself, just right with nothing lacking and nothing extra. From the Zen perspective, this ensō tells us to live fully in the present, with what we have, and not get concerned with the merits and demerits of this and that. Rōran was a Sōtō Zen master who served as chief priest of Kōshō-ji in Uji. He was a well-known (and controversial) scholar. Rōran spent his last years living in quiet retirement at a hermitage. This is a masterpiece of Zen calligraphy—bold, bright, and confident.

K226 hanging scroll 142 cm × 70 cm, ink on paper 47.6 cm × 56.2 cm.

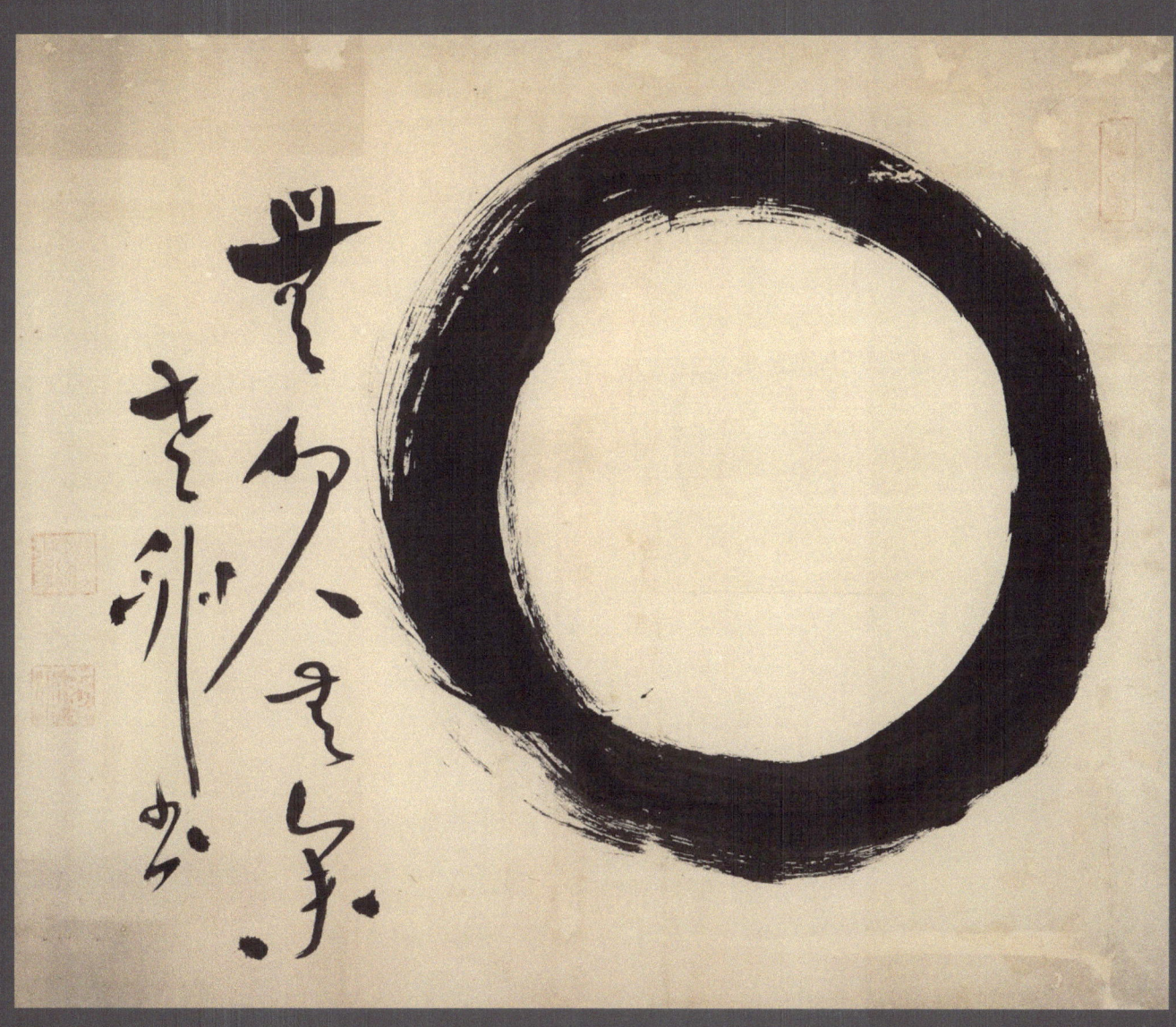

GŌCHŌ Kankai (豪潮寛海, 1749-1835)

Ensō calligraphy

Inscription:

無
一
物

沙門豪潮書

NOT ONE THING

Brushed by Monk Gōchō

This a classic ensō brushed in Gōchō's unique style using thin blush-gray ink. That kind of ink gives the brushwork a soft, luminous quality. The placing of the inscription makes it appear as if the ensō is floating. Although this ensō is a zero, from that emptiness "inexhaustible treasure" springs forth. As is the case with a good Zenga, there are many possible interpretations, and it is up to each individual viewer to come up with his or her understanding of the meaning. Gōchō, a wonder-working Tendai high priest, was unusual in that he did both classic Buddhist icons and uninhibited Zenga.

K502 hanging scroll 190 cm × 32 cm, ink on paper 121.5 cm × 29.5 cm.

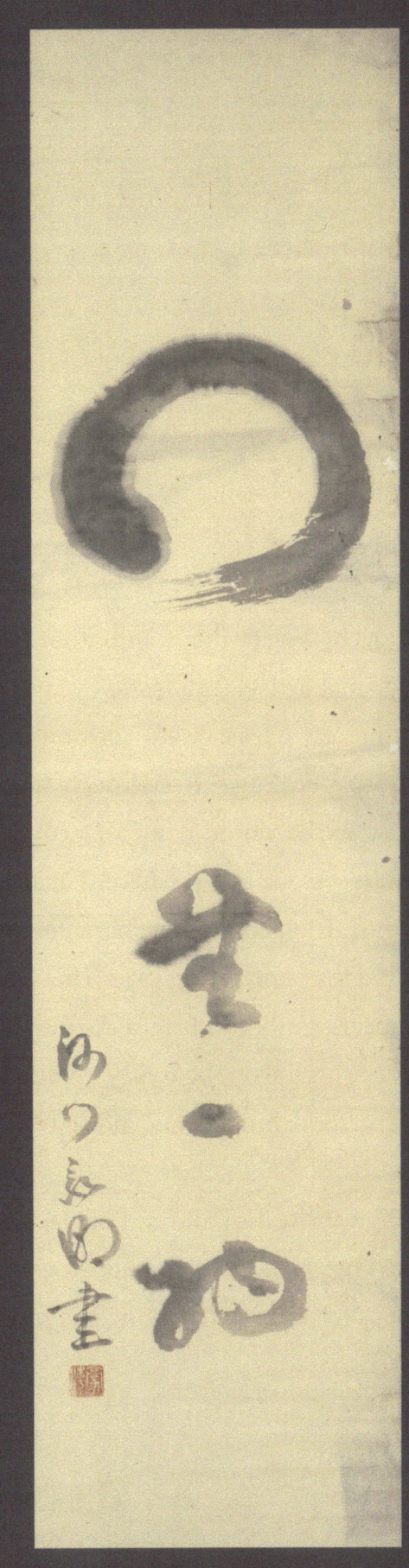

FŪGAI Ekun (風外慧薫, 1568-1654)

Daruma

This is a "Right-Facing Daruma" by Fūgai, the grandfather of Zenga. Previous to Fūgai, Zen paintings were done by professional artists (monastic or lay) who did works on commission. Fūgai, however, did his paintings to act as visual sermons, a means to represent Buddhist teachings with brush, ink, and paper. Fūgai lived much like Daruma, meditating in caves. Whenever Fūgai needed provisions, he would hang a Daruma painting outside his cave to be exchanged for rice and vegetables. As we can see here, Fūgai was an excellent artist. (It is not clear where he learned to paint.) The prominent characteristics of Fūgai's Darumas are the finely brushed beard and hair and the penetrating gaze. This Daruma is in quite good condition for a Fūgai Zenga, and still appears fresh and bright despite being 350 years old. Fūgai was a Sōtō Zen monk who spent most of his life on the road or living in caves. Fūgai used a skull bowl to eat with and to serve his guests food, but he was said to be always cheerful, never grim.

Fūgai typically placed his seal high above his paintings of Daruma as we see here. An inscription would be added on top, next to the seal. Occasionally, however, Fūgai did not get around to adding an inscription, or perhaps felt that the painting has more impact without one.

K519 hanging scroll 126 cm × 27 cm, ink on paper 48.5 cm × 25.1 cm.

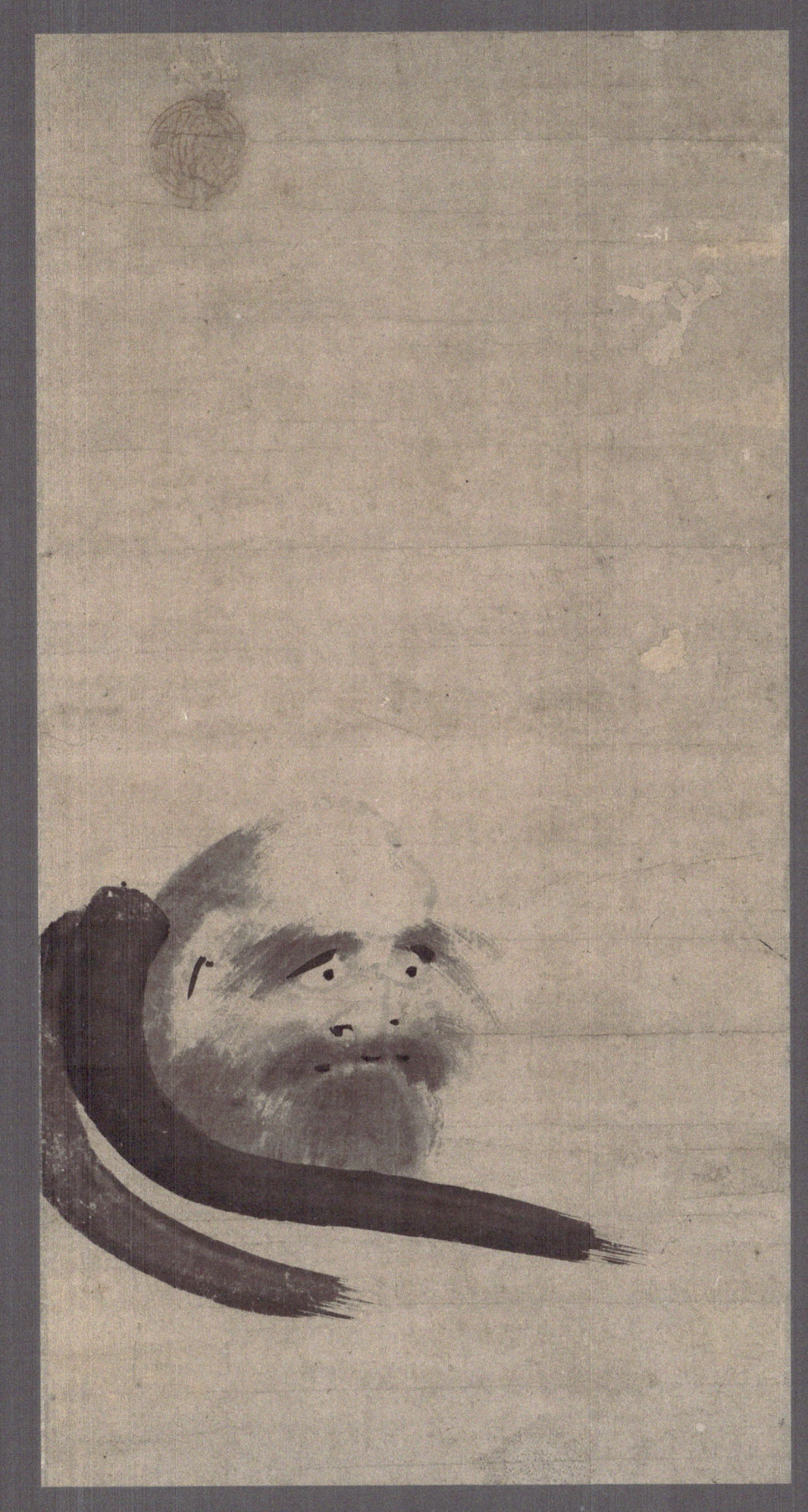

HAKUIN Ekaku (白隠慧鶴, 1685-1769)

Side-view Daruma

Inscription:

<div style="text-align:center">
竹

の　気　や

子　に　ぶ

が　か　丹

　　々や　ら

　　る　ら　め
</div>

<div style="text-align:center">

take no ko ga
ki ni kakaru yara
yabu nirame

If a bamboo shoot
is not watched
it won't see straight

(sealed) Hakuin Ekaku

</div>

This is a signature piece by the greatest of Zen artists, Hakuin. It dates from Hakuin's mid-sixties, and it depicts the Grand Patriarch Bodhidharma meditating in a cave while seated on a grass mat. There are a number of puns in Japanese in the verse that are difficult to translate, but the essential meaning is: "I'll be keeping a close eye on you so you better grow straight and tall (as Zen students)." Hakuin painted this theme many times, but each Daruma is subtly different. Many are quite severe in expression, but this one is almost whimsical yet at the same time bristling with quiet power. Hakuin is considered the greatest Rinzai Zen master of the last five hundred years, and he is mentioned extensively in almost every publication on Zen Buddhism. In addition to teaching hundreds of monastics and laypeople, Hakuin was a talented and prodigious Zen artist who considered each one of his works to be "visual Dharma," images to help sentient beings achieve liberation.

<div style="text-align:center">

K206 hanging scroll 177 cm × 37 cm, ink on paper 84.5 cm × 24.5 cm.

</div>

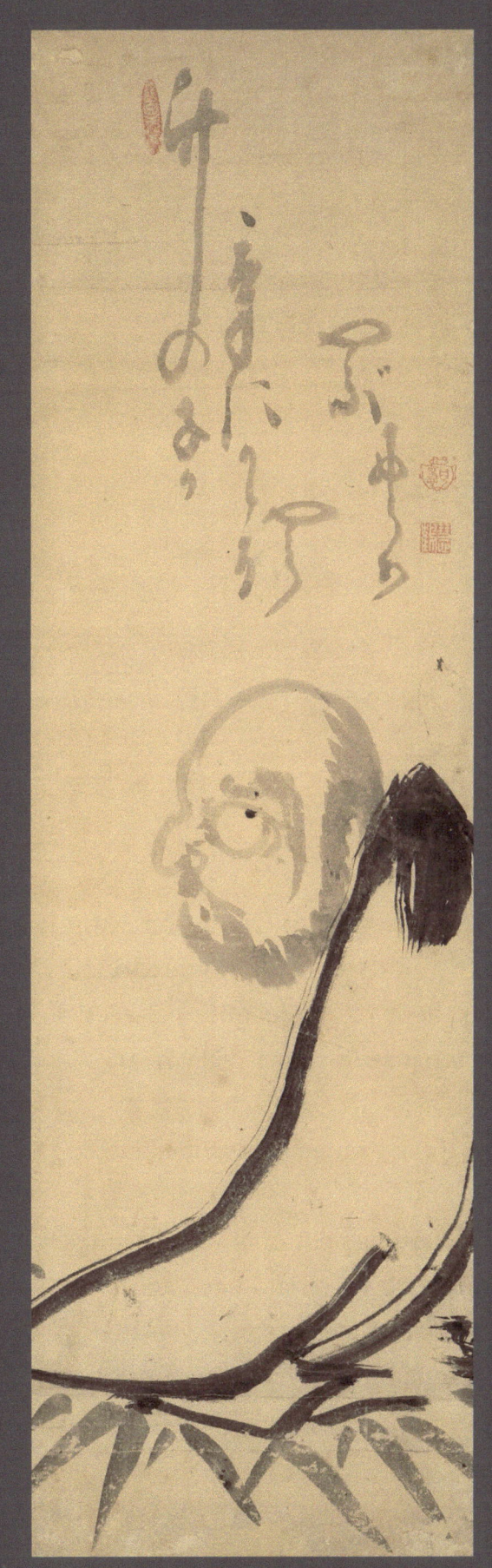

SENGAI Gibon (仙厓義梵, 1750-1837)

Daruma

Inscription:

<div style="text-align:center;">
雖遐甚邇

東西十萬里

帰乎隻履

渡乎一葦
</div>

<div style="text-align:center;">
厓道人拜画供題

（花押）
</div>

[Daruma] crossed over [to China] on a single reed;
He returned [to India] with a single sandal;
It seems as if there 10,000 leagues between East & West
But actually what seems far is very near.

 Respectfully painted & inscribed by [Sen]gai, man of the Way

While Hakuin's portraits of Daruma are rather intense and severe, Sengai's Daruma paintings depict the Grand Master as being more laid back, more of a Daoist immortal than a severe Buddhist patriarch. This is one of Sengai's best Darumas, with his gaze fixed right on the viewer. The inscription is prophetic: Daruma [Zen] came from India to China, and then on to the Western world. Eastern and Western cultures seem to be miles and miles apart, but in fact human beings are essentially the same everywhere, and all of us need to wake up to our Buddha-nature.

 K508 hanging scroll 172 cm × 46 cm, ink on paper 66.8 cm × 34.4 cm.

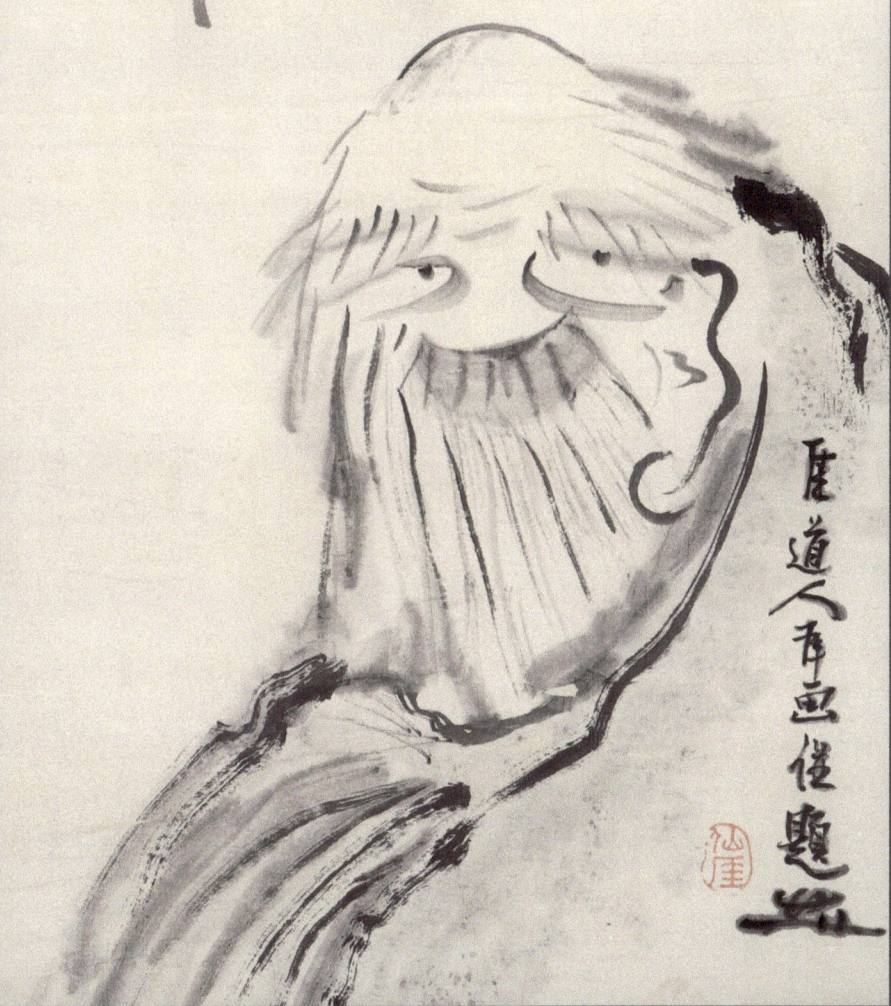

DAIKŌ Sōgen (大綱宗彦, 1772-1860)

Wall-gazing Daruma

Inscription:

面壁乃祖師のす可多ハ
山しろのこまの宇里の
似かなす比可

七十九大綱拝書
（花押）

menpeki no
soshi no sugata wa
yamashiro no
koma no uri no
niru ka nasubi ka

The form of the wall-gazing Grand Patriarch—
Doesn't it resemble a tasty melon or
Eggplant of Yamashiro District?

Respectfully brushed by 79 year-old Daikō

This delightful piece, graced with Zen humor, depicts Bodhidharma, the Grand Patriarch of Zen, facing the wall of his cave as he contemplates the Absolute. The inscription, however, brings the loftiness of Buddhist meditation down to earth: "Daruma from behind looks like one of the big melons or eggplants grown in Yamashiro." In other words, do not focus exclusively on the Grand Patriarch's form—take the tasty inner core of his teaching, not the skin. Further, if sitting still is all there is to Zen, eggplants and melons have it made as Zen masters. Daikō, a Daitoku-ji abbot, was a poet, calligrapher, and master of the tea ceremony.

K065 hanging scroll 116 cm × 48 cm, ink on paper 30.4 cm × 42.2 cm.

画俺乃祖師のすかた
うつのこまにこまの
仙ぞるすれう

七十九太調枝書

DAIKŌ Sōgen (大綱宗彦, 1772-1860)

Zen Tōfu

Inscription:

世の中ハ豆で四角で
やわら可で豆婦の様な
人耳な連人

八十五翁大綱

yo no naka wa
mame de shikaku de
yawaraka de tofū no yō na
hito ni nare hito

In this world
Soybeans can be shaped
Into a soft square;
People too should be
Just as flexible.
The 85-year-old fellow Daikō

This is Daikō's signature Zenga. The composition is as simple as it can be, and the subject concerns a basic, everyday dish in the Japanese diet but, as always, the Zenga has a deeper meaning: in their raw state soybeans are hard to chew and digest, but when they are boiled they become palatable and can be shaped to fit any container. People too can be stiff and hard to deal with but when they are flexible in thought and action things go much better in the world. Also tofu is inexpensive to make, delicious, and healthy—a perfect Zen food. Daikō was 435th Abbot of Daitoku-ji in Kyoto, one of Japan's most famous Zen temples. In addition to being a fine poet and calligrapher, Daikō was a master of the tea ceremony, and his brushwork is highly prized by connoisseurs.

K469 hanging scroll 110 cm × 46 cm, ink on paper 30.4 cm × 42.2 cm.

世の中ハ豆て四角て
やもつて豆腐の枠を
人すきき人

竹田小稿

GANSUI (岩水, 19th century)

Calligraphic Talisman Dragon

DRAGON

This is a fantastic example of the kind of calligraphic dragon that was brushed by a virtuous monk or mountain priest to serve as a talisman to protect a household from natural and man-made disasters. This dragon is especially large and dynamic, overflowing with energy and composed with one mighty brushstroke. No information on the artist but, judging from the style of calligraphy and the names on the seals, it was likely done by a wonder-working *yamabushi* (mountain wizard).

K448 hanging scroll 187 cm × 65 cm, ink on paper 114.0 cm × 51.6 cm.

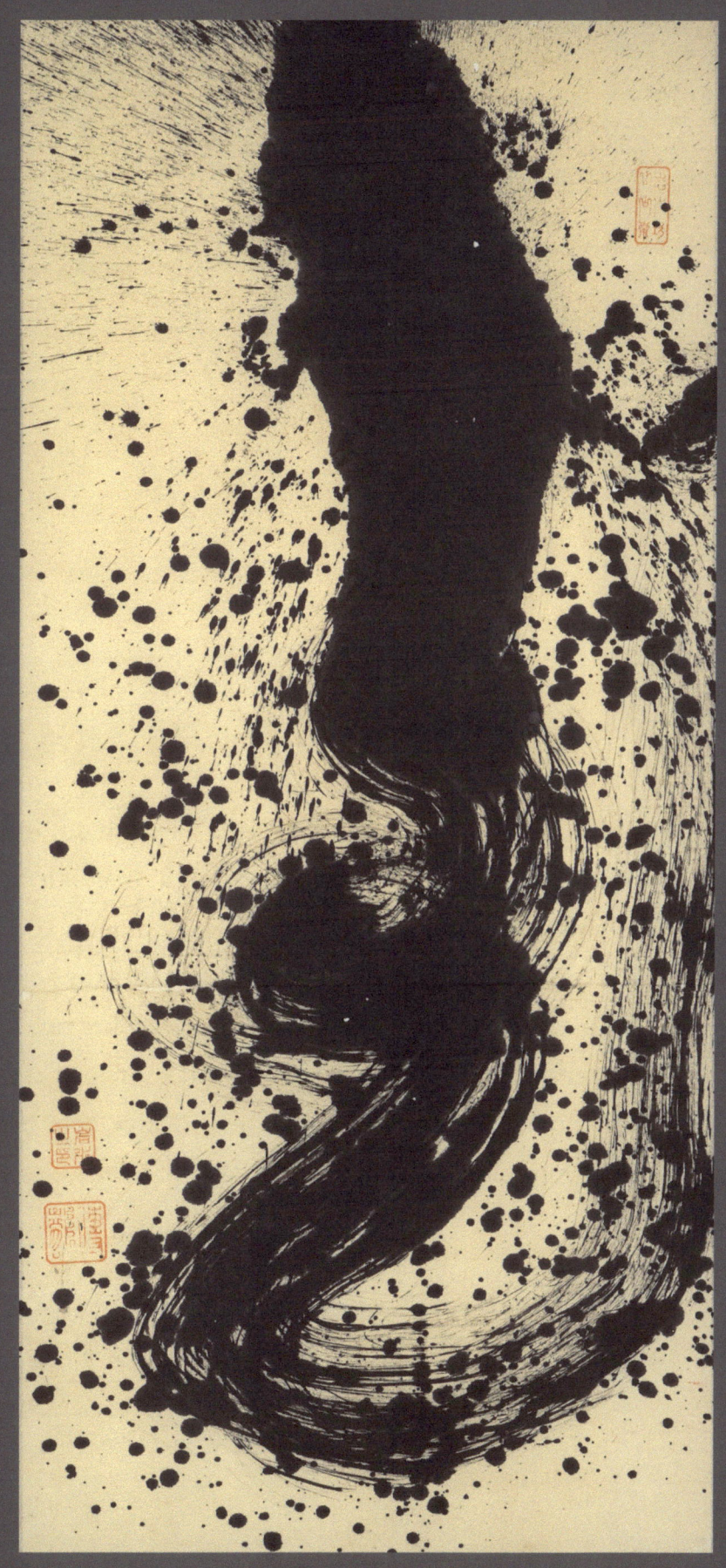

Zuikō CHINGYŪ (瑞岡珍牛, 1743-1822)

Dragon calligraphy

<p style="text-align:center;">龍</p>

<p style="text-align:center;">DRAGON</p>

This is an outstanding example of a dragon scroll serving as talisman. In old Japan, eminent monks or mountain priests were often called upon to brush a dragon to serve as a good luck charm for a family. This particular scroll is both a painting of dragon and the kanji character itself. The dragon seems to be floating, in the air or water, and actually appears to be alive. The mounting is excellent, the patina deep and even, and the brushstrokes rich and bright. Chingyū served as abbot of a number of Sōtō Zen temples in his career, helped revitalize his sect, and published many important books. Chingyū, known for his creative, zany brushwork, produced many fine Zenga paintings himself and did a number of collaborative works with other Zen artists, such as Gōchō.

K320 hanging scroll 121 cm × 62 cm, ink on paper 31.2 cm × 51.8 cm.

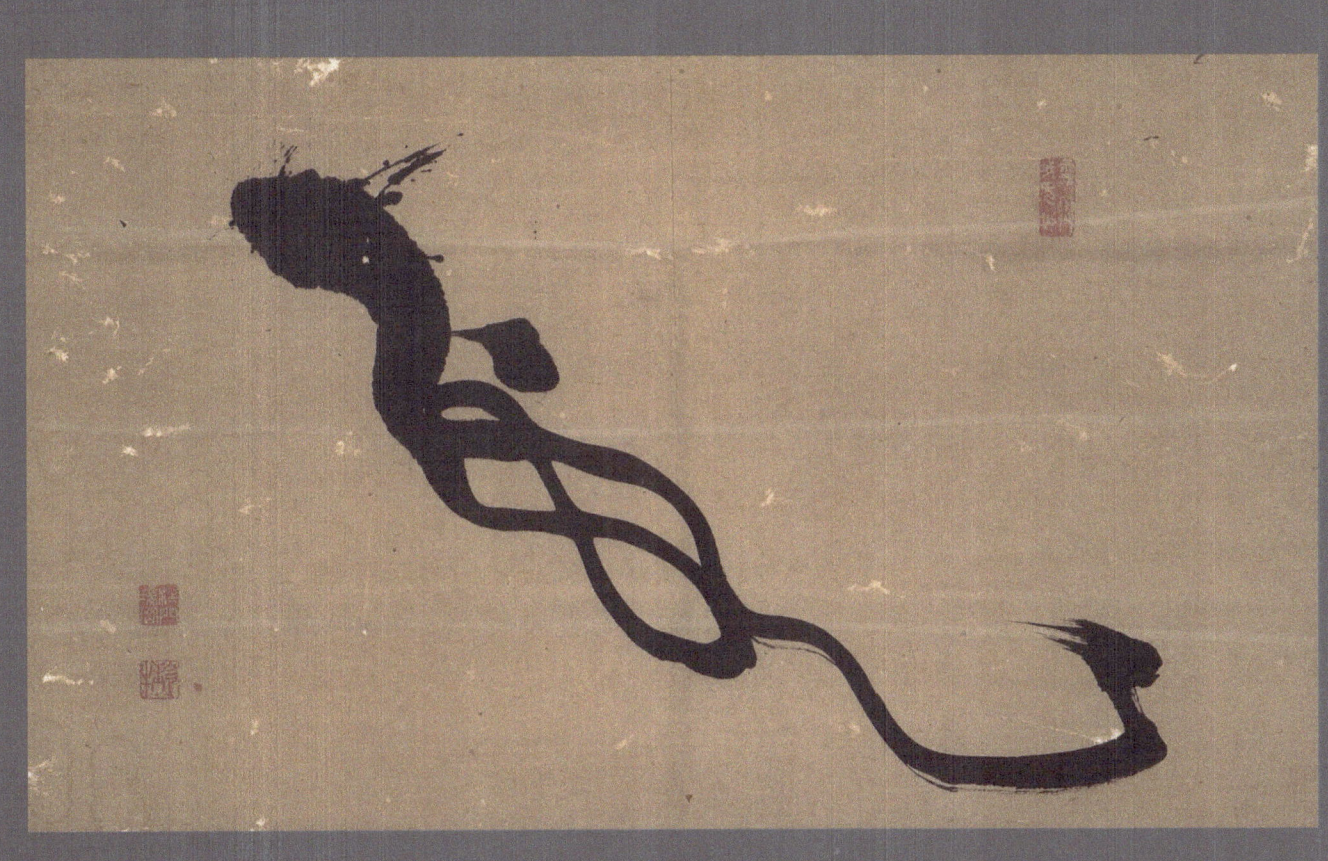

Yamaoka TESSHŪ (山岡鉄舟, 1836-1888)

Zen Dragon / Mt. Fuji

Inscription:

龍

鉄舟高歩書

DRAGON

Brushed by Tesshū Kōhō

This is one of Tesshū's signature Zenga, a calligraphic ascending dragon soaring above Mt. Fuji. The dragon is meant to serve as a talisman, and Mt. Fuji is the timeless, auspicious symbol of Japan. From a Zen perspective, *fuji* is read as 不二 "not-two," that is 'non-dual," representing the unity of the nature of the natural world and Buddha-nature. The dragon represents soaring above all temporal and petty concerns. In terms of output and quality, Tesshū was the greatest of samurai Zen artists. He was a master of the sword, the brush, and Zen, and although he died at the age of fifty-two he produced well over a million pieces of Zen art.

K476 hanging scroll 183 cm × 47 cm, ink on silk 113.1 cm × 34.6 cm.

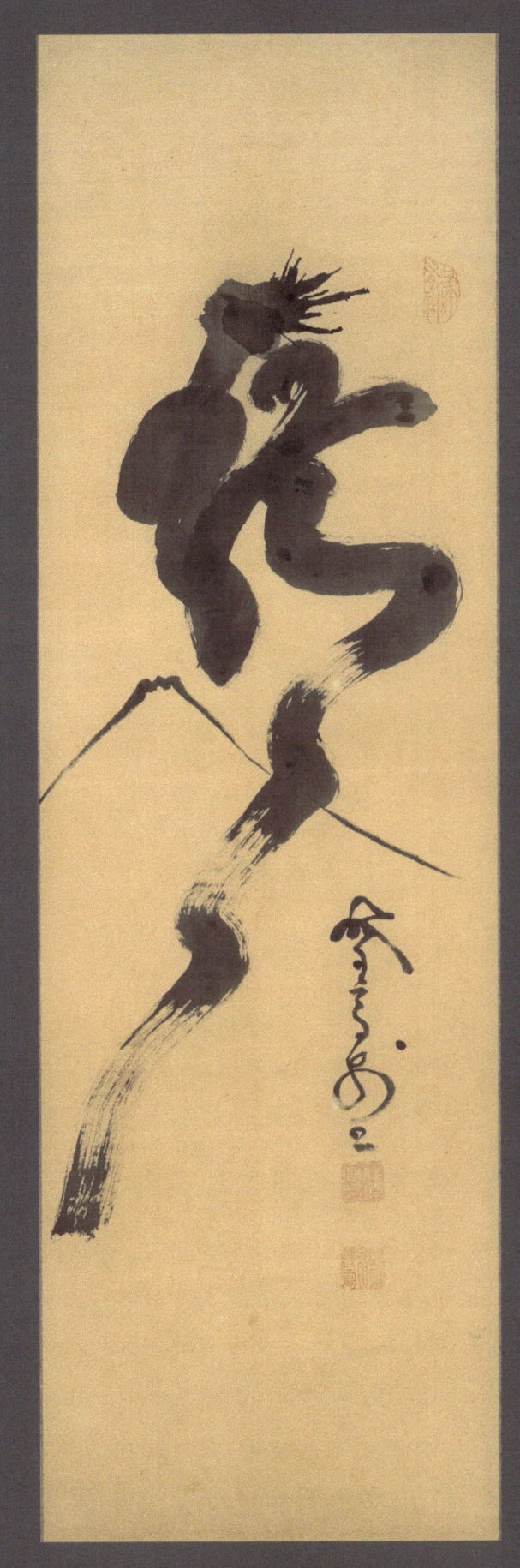

SENGAI Gibon (仙厓義梵, 1750-1837)

Zen Fuji

Inscription:

<div style="text-align:center">
天地の間に

二ツなき

ものハ

我が

日の本の

不二の阿けぼの

厓 (花押)
</div>

tenchi no ma ni
futsu naki mono wa
waga ni no hon no
fuji no akebono

Between heaven and earth
There is nothing like it:
The sun rising over Fuji
Of our land
Ni-no-Hon.

[Sen]gai

This beautiful Zenga is one of Sengai's finest. *"Ni-no-Hon"* means source of the sun; the rising sun is depicted here peeking out from the foot of Fuji on its way to the center of the sky. *"Fuji"* is "not two" (不二). In Zenga, this term represents the non-duality of one's particular nature with universal Buddha-nature. Sengai emphasizes that point here: "*Waga*" can mean both "our" and "mine." Together with Hakuin, Sengai is the greatest of Zen artists. Sengai created Zenga on every possible subject (including sex and using the toilet). His work has been widely exhibited in Europe.

K499 hanging scroll 117 cm × 66 cm, ink on paper 34.1 cm × 57.0 cm.

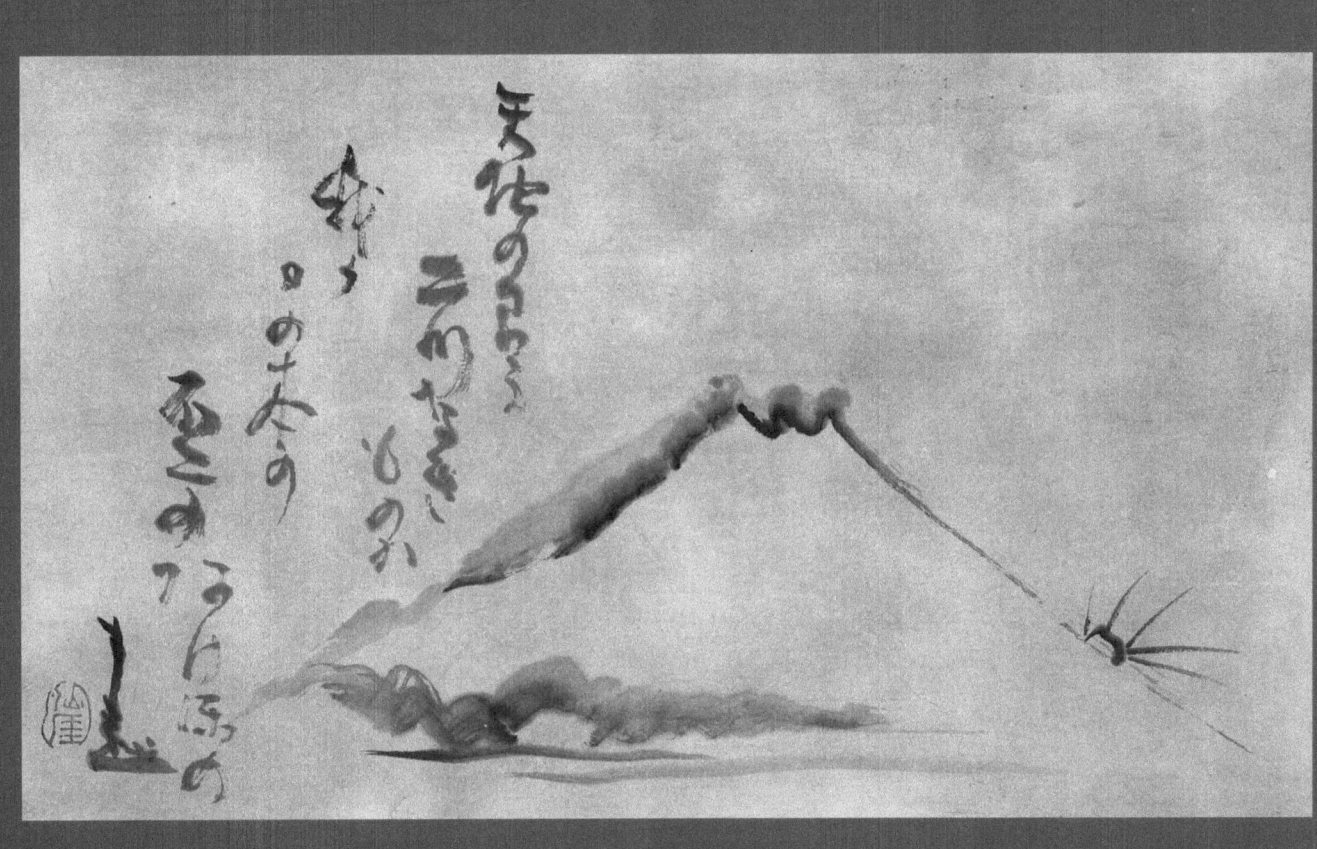

UNMON Sokudō (雲門即道, 1690-1765)

Zen Staff

Inscription (which consists of only Unmon's signature):

勅
応
霊
鷲
雲
門
書

Brushed by Imperial Delegate Unmon of [Mount] Ryōju *

* = Sesson-ji, a temple originally founded by Shōtoku Daishi and restored under imperial command by Unmon

The staff is an all-purpose Zen tool—a symbol of authority, a walking stick, an implement for imparting discipline. Unmon was a Sōtō Zen abbot. He had many students, and thirty-six Dharma-heirs.

K085 hanging scroll 198 cm × 71 cm, ink on paper 130.3 cm × 56.4 cm.

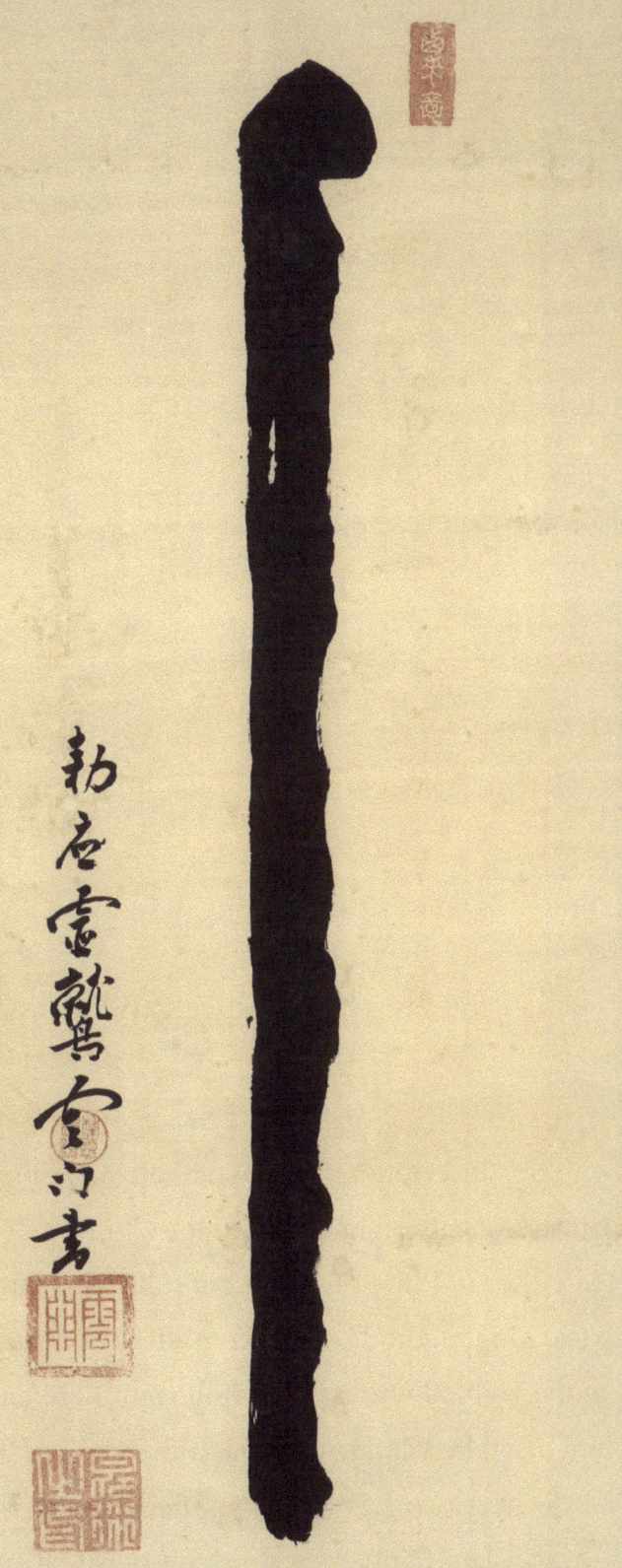

TŌREI Enji (東嶺円慈, 1721-1792)

Zen Staff

Inscription:

<div align="center">

道得三十棒不道得
亦三十棒 東嶺(花押)

</div>

 Speak and you will get 30 blows; don't speak and you will get 30 blows again!
 Tōrei

A painting of a staff with this inscription is a classic Zenga, painted in every generation of Zen artists since Hakuin. The tale itself originated with the Chinese Zen master Tokusan (780-865), who is always depicted either holding or using his staff. The staff symbolizes the demanding and uncompromising teaching methods of a Zen master: "Don't try to fool me with glib words or cagey silence. Show me your Zen understanding right here and now!" Together with Suiō, Tōrei was Hakuin's chief disciple. While Tōrei was a meticulous scholar, in his Zenga he cared little about refinement; his brushwork is totally unaffected, almost wild, an expression of pure Zen spirit. The "happy face" *kaō* (cipher used in lieu of a seal) under his signature is Tōrei's trademark.

 K475 hanging scroll 178 cm × 4 cm, ink on paper 91.3 cm × 5.8 cm.

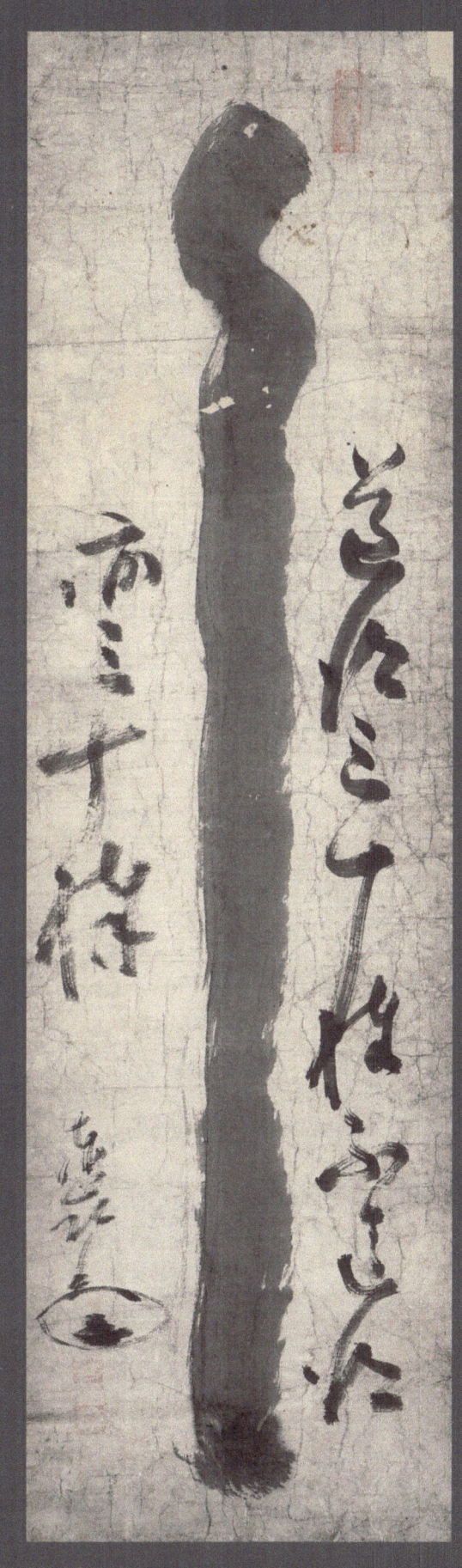

Ishikawa JŌZAN (石川丈山, 1583-1672)

One-line Calligraphy

Inscription:

ICHI	一	One
NEN	念	Thought
SAN	三	Three
ZEN	千	Thousand

Ichinen sanzen, "One Thought Three Thousand," is the pillar of Tendai and Zen Buddhist philosophy. *Nen* means "thought" in the sense of insight or perception manifest in one's being, mentally and physically. A single profound, awakened thought allows one to perceive and experience all the 3,000 realms of existence of past, present, and future. Such a vision encompasses everything, from the tiniest atoms to the largest galaxies. Another interpretation is that in each thought, there are three levels: empty, provisional, and middle. Each level has a thousand dimensions, making three thousand that are linked together in one instant of thought. The calligraphy itself is a variation of the distinctive clerical style script that Jōzan perfected. Ishikawa Jōzan was a renowned scholar, poet and calligrapher, in the Chinese style. He is most famous for having designed a retreat he called Shisendō, "Hall of the Immortal Poets" on the outskirts of Kyoto. The buildings and garden are among the most beautiful in Japan.

K536 hanging scroll 223 cm × 59 cm, ink on paper 131.1 cm × 46.3 cm.

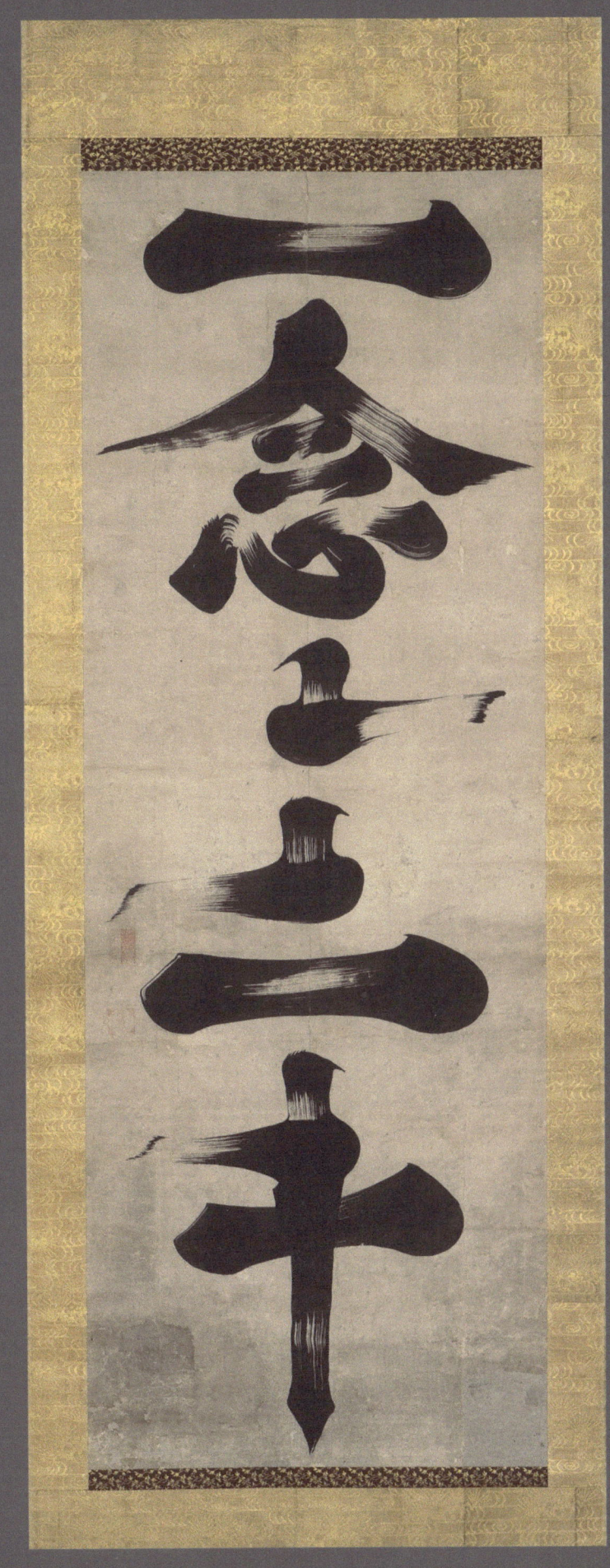

SEALS (real size)

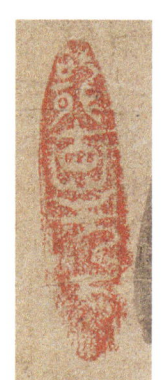
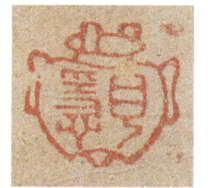

K502
Gōchō
(1749-1835)

K021
Tokuō
(1649-1709)

K226
Rōran
(1724-1805)

K206
Hakuin
(1685-1769)

K519
Fūgai
(1568-1654)

SEALS (real size)

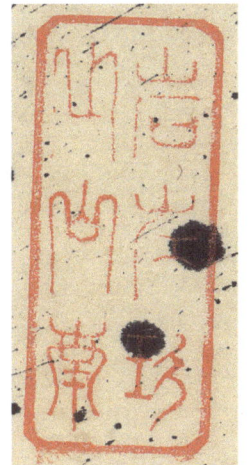

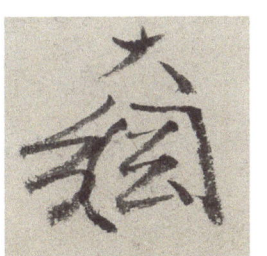
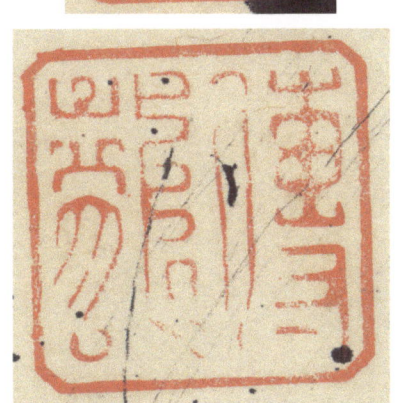

K065 *kaō*
Daikō
(1772-1860)

K508
Sengai
(1750-1837)

K448
Gansui
(19th cent.)

K320
Chingyū
(1743-1822)

K469 *signed*
Daikō
(1772-1860)

SEALS (real size)

K085 Unmon (1690-1765)

SEALS (real size)

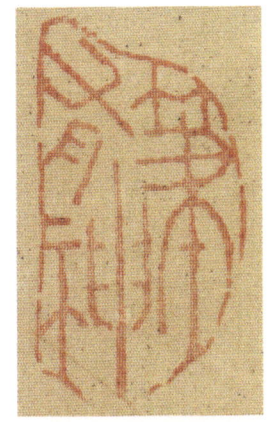
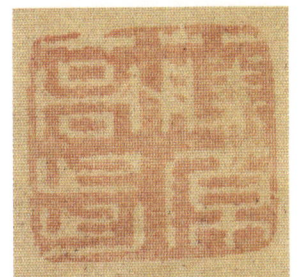
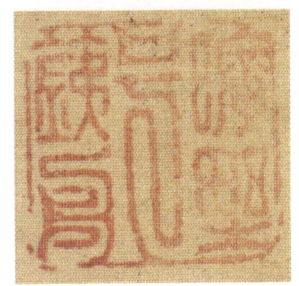
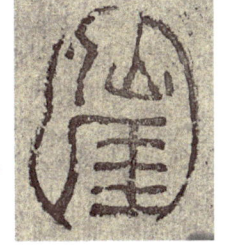

K476 **K499** **K475** **K536**

Tesshū Sengai Tōrei Jōzan

(1836-1888) (1750-1837) (1721-1792) (1583-1672)

© 2011 **Kaeru-An** & authors

Zen art information: John Stevens
Zen art photography: Felix Hess

contact:
jstevens@shambhala.com
fhess@xs4all.nl

www.ingramcontent.com/pod-product-compliance
Lightning Source LLC
Chambersburg PA
CBHW051101180526
45172CB00002B/733